Published by **Lost Alphabet**

With offices at

1603 Capitol Ave.
Cheyenne, WY 82001
United States of America

www.lostalphabet.com

ISBN: 978-0-9985602-0-5

Library of Congress Control Number: 2017930064

Printed in the United States of America

*We doubt the call
even as we answer it.*

M.R. Morrison

dedicated to:
my grandmothers

Contents

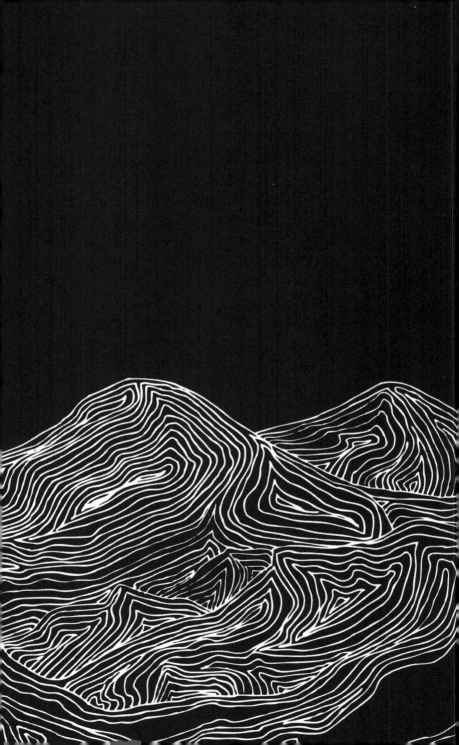

"It came like dawn,
very slowly and all at once,"
I said.

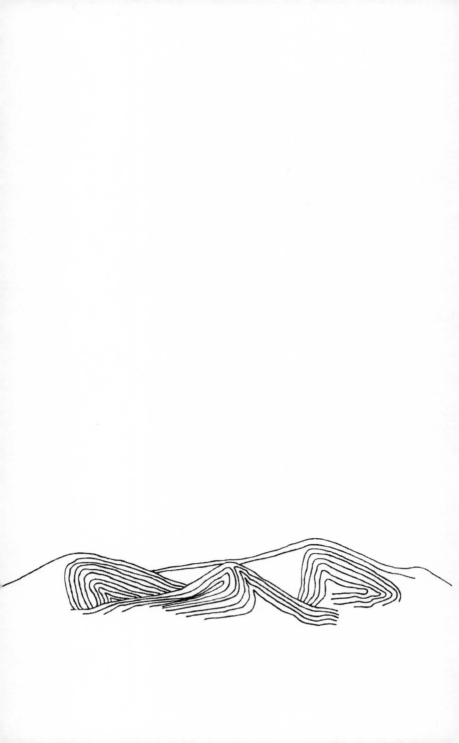

1.

I found her hanging from a copper coil
in the branches of a tree above a puddle
of velvety sage green moss
suspended like a crystal in a sunbeam refracting,
the knowing old southern soil in her eyes.
I wove her into a tapestry
of syllables in warm earth tones.

I found him like a flock of plastic bags,
rattling from the skeletal branches of tree limbs,
in the wind of collective thoughts.
It's always the harmless things that hurt most
circumstance, a child
holding a mirror to the world.
I made him the footsteps of the Sun
on the silver screen of crackling static and gray.

Most people looking for recreation
come with tears in their eyes.
Subtle complexities of stubborn growth,
the image eclipsed by the word,
before the invention of perspective
we were merely craftsmen.

2.

The road unwound into me
as the raw redness of the sky
started to turn purple
like the black-eye above
the posy planes of
a young girl's blushing cheeks.

Most lovely and lost
they sit yawning on front porches
in the humid evenings of
middle America. Lonely, in
all their boxed up glory, sipping
the cooled Earl Grey myths of the West.

In the permeable darkness of indoors
I flicked the switches of the lights on
in two yellow papered rooms,
but not the one I am in
where I sit splitting hairs
to differentiate between the grays.

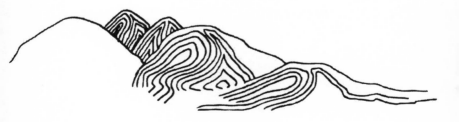

Boys on bicycles pass making verbs of nouns.
While rising fireflies are trapped in mason jars.
Air tight, surrounded by the night,
illuminating tin cans on strings that whisper
about the contours of this stale life
both suggestive and vague.

I close the door, returning to the road as
the heavens now an inky blue descend
on the horizon and husk of my flesh.
The days of wrath are always yet to come.
The scent of yellow lingers under my finger nails,
reminding me that there will be a dawn of bitter
fruit.

I accelerate creating a breeze, self soothing
my flushing limbs, the hood compass points to
the land where they still let children cry
my hands on the wheel I slip
into another's reveries as my left tires
smooch the dash dash of the yellow line.

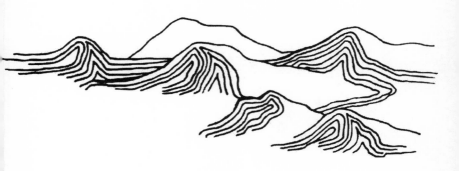

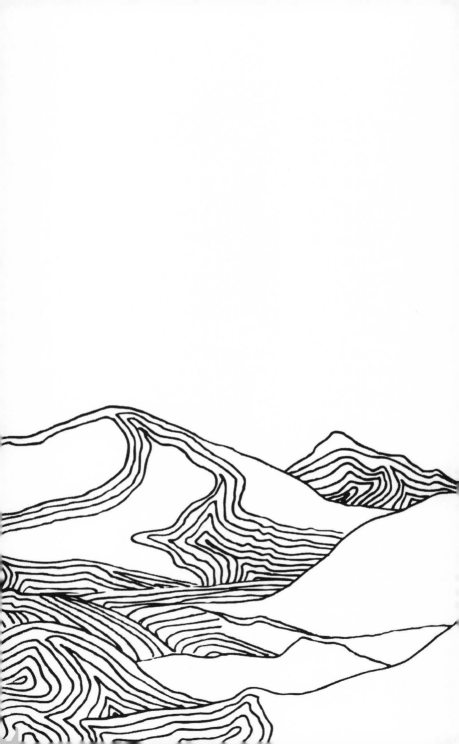

3.

Thinking from left to right
escaping gravity through film,
Dear agony,
 I thank you for what you have taught me
of your brother bliss.
We don't know our own traditions,
"light the fire in the thicket,"
ecstatic pilgrimage in deep delta blues
deep fried in their habits.
If you can't say the words
you let them drip from your fingers
like grease from corner shop burgers and fries,
with the silent dignity of buttonholes
our senses shifting their animistic participation
hearing voices from marks and forms
crafted from the lips of those men
who wove creation and sin inseparable.

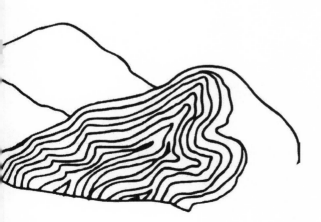

4.

He needed the clarity of morning
the tart lines gathering on the horizon
those pale fingers pulling at the strings
of the gray Venetian blinds of dawn
bringing the logical geometry,
a city in silhouette.
Even the smoke stacks
in the distance seem to have
a structure unencumbered
by the whims of coincidence.

He slept with the TV on
 sometimes the radio too
on low. anything to drown out
voice on repeat "..." [repeat] Since
he moved to the city, her image
could only tarry in his mind
away from the familiar landmarks
her loitering shadow flitted,
always one streetlamp ahead, a
fair skinned & almond-eyed brunette,
but he remembered how the
sun revealed
the forest in her eyes
and the fire in her hair.

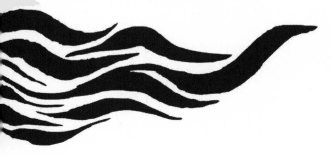

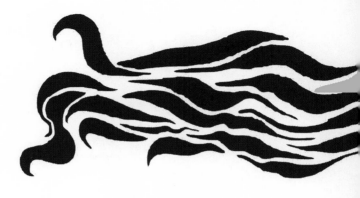

In his sleep his elbow brushed
the soft butter of her hip,
unconsciously,
fluttering industrial parks off
exit nine seen through the
weaving pines of a memory.
She spent that whole year worrying
if the sky would really be blue there.

The main road of his life had, at this point,
many side streets and alleys
several seemed the most delightful place
to smoke and reminisce
with the earthy tones of nostalgia:
rubber, rust, and polaroids.

"The truth of the matter is,
doubt never cast a shadow,"
he said.

5.

What is it for me to be
at the long beginning of a new life,
when I know nothing of the old.
This language is older than those fixtures,
a stigma of neon ideologies
from which florescent light falls
on our upturned faces.

Classified rituals of uselessness,
contain our moments of immortality.
Like Orion hanging upside down
at the zenith of the sky, sometimes
I go to the river and lay upside down
with my hair in the flow.
How else do we know water,
unless it is contained?

There like a red-blood cell in the veins of God
I cling to the banks, as if I have faith,
as if I have free will,
as if I have that which slips
through my flushed fingers
each time they begin
to close around it.

6.

Disillusioned children in a
waning fertile crescent, we wait.
Our pale pink politics court radioactivity
leaving us feeling warm and restless.
Soaking in the oil springs of
our pours to mud.
Reverting to all fours
we dig holes
in hopes of finding
Heaven.

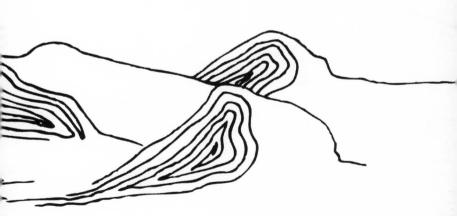

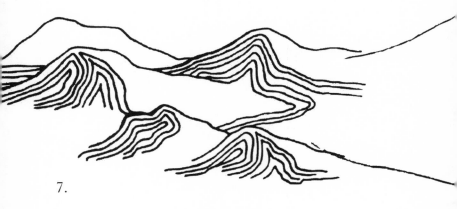

7.

The savage past stuffed into fedoras
felt worn in winding labyrinth tunnels
eating our quantum libidos to embody their mojo.

As earmaked scapegoats
keep dancing till it rains,
fading in the twilight.

Sage pages sprout out of
the imposed wallflower patterns repeating
in each budding theory.
Ivy clinging to the superiority of its anxiety
at the bricks of institution and tradition,

appealing to reason and faith
with the moral gusto of a
starving child's wide-eyes,

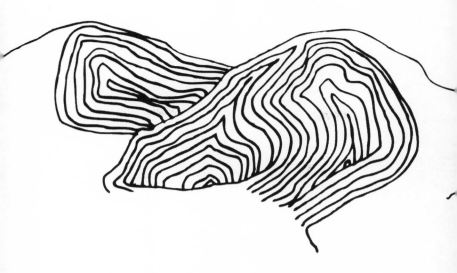

evolution fit like a dusty puzzle piece
in the Victorian mind set,
a progressive savagery, from clubs to pens.

We
dripped wax on God's naked flesh,
our Psyche's cloaked husband,
tricked by our jealous sisters
into questioning the wings that bore us hither.

Savage reason in ornate veneer boxes
reading parody by alter light,
in small hours.

Historical evolution
a single-celled God
dipping its toes in Heraclitan rivers.

Sacred and Profane,
Projected and Contained.

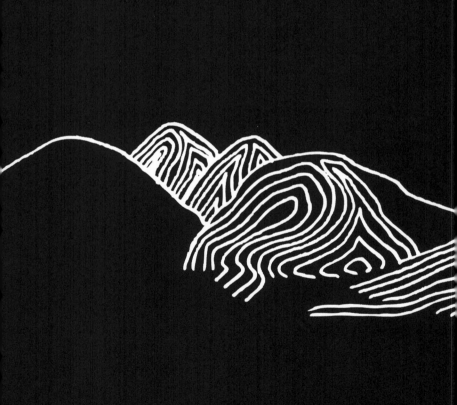

"We order the meals
we think the other will eat,"
she said.

8.

You Can't Stop the Machine

They don't understand
why I don't need them
their mamas made sure they left
with a bible and a smile.
None of us know who
ended up eating the apple for teacher.
Its crisp green curve lingered
in our watering minds
as we lay slouching, the engine humming.

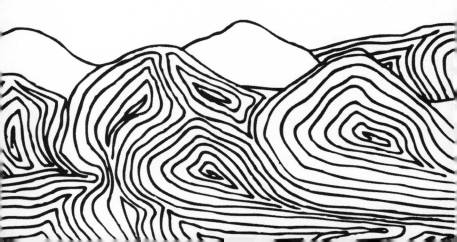

Our heads dangling out the windows
75mph winds wiping away the bitter side
of whiskey, the sweet sting coming to rest
deep in our throats.
With the warmth of news paper suns,
weathered yellow against
the gray print
climbing conversations resembling
shed lock combinations
remembered years later
in the minds of old men.

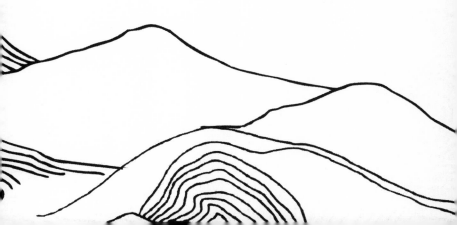

She said "hmmmm" and really listened
to it echoing about her soul
leaving the rest of us in a world
its silent spin stopped.
"You can't stop the machine"
he screamed with all his lungs,
forcing the spin to resume as
the first bird began to warble its marry tune.
He searched her face for his fate
She's from the land where you still hear the cry
He worked at a button factory, when they met.

As I walk in the blue green drizzle
of yesterday afternoon, I recall images
of her walking toward us
with the word to make us silent.
The ghosts in my mouth chill my breath.
as my ears tingle with the echos of
tangled triangles of zen,
verbs cried from the closed mouths
 and open eyes,
of these polyester children,
when the power is out.

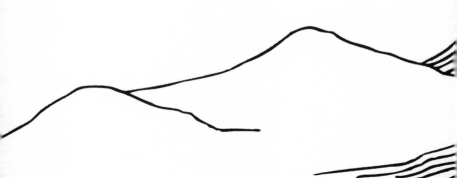

9.

You and the ocean,
both salt and water,
both rocked by the moon.

12.

The rocks clink in the mug as
he climbs the descending mechanical stair.
They sit in diner booths
next to conversations
from nowhere.
Her disguise is a short skirt.
They both order the meals
they think the other will eat.

She could always give
the most concrete of acts
an abstract meaning and
her dissatisfactions a political name,
selling people possible futures for their pasts.

He was for her
the blank white spaces at the edge of the print
between stories, before dreams.
The sounds she heard in the
silence of suburban life.
Tenths of seconds gazing back at her
quoting Duchamp and visualizing Nietzsche,
trying to pluck the strings
of her Impressionist heart.

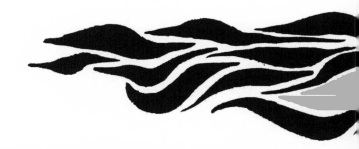

"You might call his hair silver,
if you were being kind,"
she told him once, speaking
of a mutual obsession,
which seemed a rarity.
He noted the scent of what must be roses
rising from her flushing arms
which lay on the table top.
Her elbows rested dangerously close
to the edge, her thin fingers stirred
the cream into her coffee.
He imagined that the color she was creating
with those swirling motions could resemble
the skin of future children
if their loins ever considered each other.

In the hot pink glow of the flickering neon trim
eyes downcast on the burnt coffee of her freckles,
She's like the summer that sees its own end.

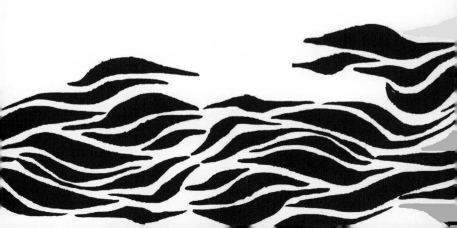

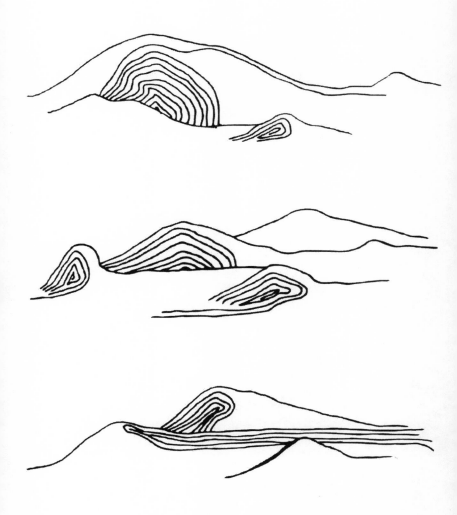

14.

Rib Cages

Her heavy summer breath
rustling the sheer curtain,
an echo of the smoke signals
on the other side of the eccentric pines.
Their lush Spring colors now bleached
by the July sun, a half-hearted white hot.

A lazy saffron eye with an obtuse view
of the world, through the cat-eye lenses
of hazy summers passed.
Reclining under the eves,
in the cool contrast of shade,
the white widow sips her cool bitter tea,
long since stained by its ancestors.
Condensation on her hour glass,
the faint taste of salt.
Glints of sunlight catching
in the mirrors of her eyes
and the web of her crossword.

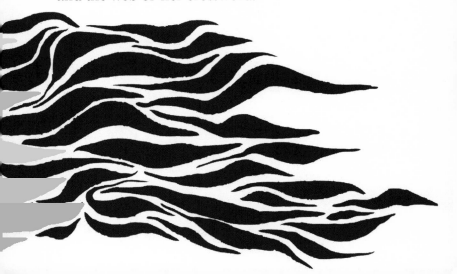

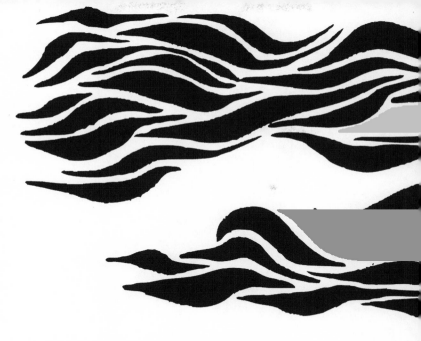

A tide of humidity creeping through the
cross hatching of the screens with a muffled crash,
giving three dimensional shape to her solitude,
a humm in the eardrum of a lonely island.
The dial tone fading in and out,
getting tangled with the wavelengths
of the sedated throb of a stranger's heartbeats
and the buzz vibrate of cicadas and cell phones on
bed side tables, a couple doors up the street.

The clouds bearing witness through the windows
to an infinite number of acts of contrition
between the thin sheets stretched over
the mattresses of modern life,
distorted into maps of realities visited
in the throws of two cages wrestling to open
themselves to the joint experience of existence.

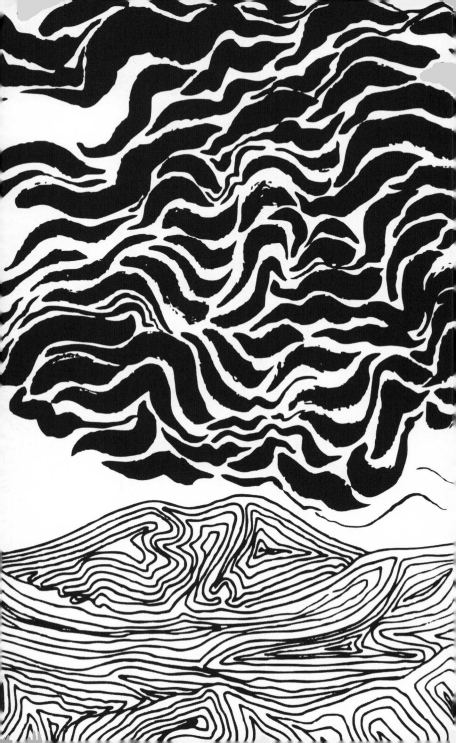

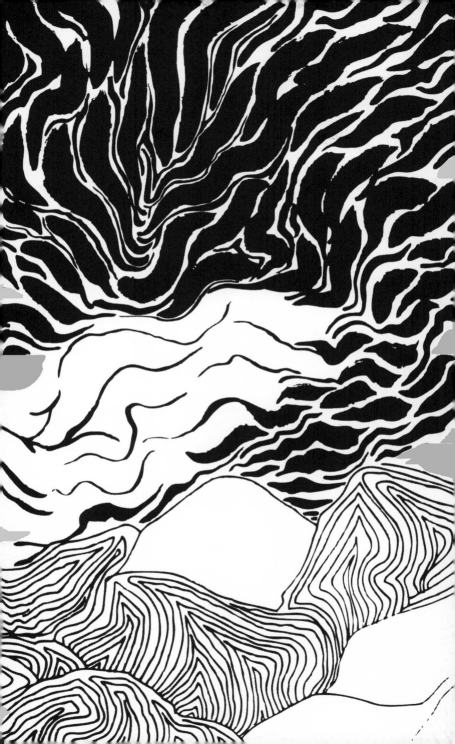

15.

I sit across from myself
We sit facing each other
and relax our shoulders,
it's been a long time since
We put down this world.

She sat across from herself
the crescent moon of the coffee stain
was the closed captions for a conversation
coming from a booth to the left of me.

We breath a deep breath
that rattles our soul.
Sometimes, she sleeps deep
in the corner recesses of a room, (when)

I've been bullfighting at midnight
waking covered in a cold sweat,
that has risen from my pores,
like a roaring crowd.

In those dark moments before the dawn,
when the sun has overslept,
I catch her watching friends
become cautionary tales.

It is always hard to tell
if she has tears in her eyes,
their color is moist and hard
to define, like the sea.

We sit in diners, across
from one another, to be alone.
To separate ourselves,
and the stories we've lived.

Every once in a while,
an old memory stumbles in,
sliding into a booth near by
placing its forehead on the table
its content spreading out like syrup.
brown, thick, sticky droplets on top
of yesterday morning's coffee marks.

And when I think she isn't looking,
I turn to see her facing me, and
she doesn't let me take the easy way
out. From that corner, she holds me
in her gaze, firmly, with a calm sternness.
And we merge, like we were never two.

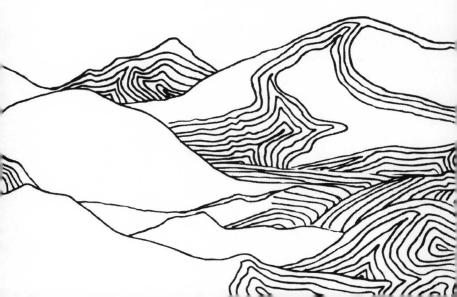

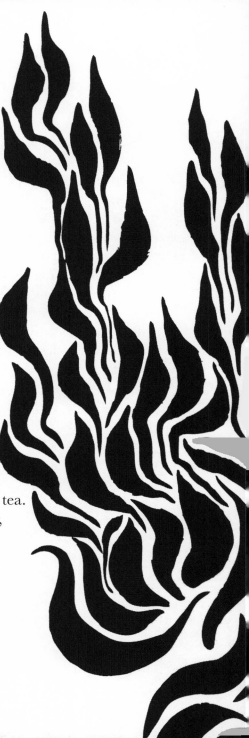

16.

In the winter of hope
she was just his cup of tea.
luke warm on a saucer,
painted porcelain lips.

She was chillingly authentic
in all her actions
pouring tea was an
unique ceremony
that steamed up her glasses
in a prophetic way.

His eyes lock on
her parted lips as
the last syllable
curved out of her mouth
rattling the latch on the door
of relocated memories.

"Rules are usually made
when they are broken,"
her stepfather always told her.

Sleeping in the shanty
of a brand new verb,
a lit cigarette falls
from sleeping fingers.
A cosmic conspiracy
contained in a falling ember..

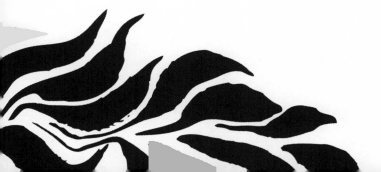

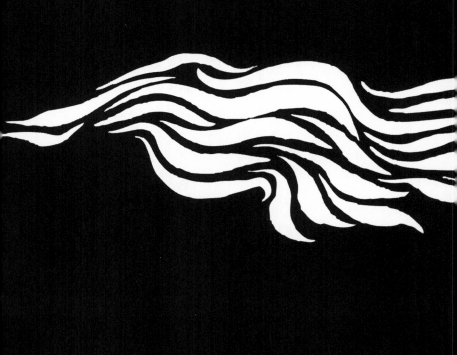

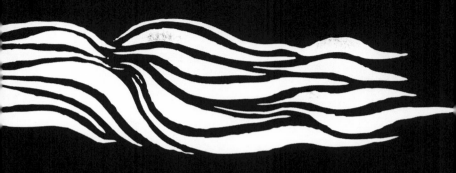

"Because it's the only thing
that really makes me feel badly,
when I am alone,"
you said.

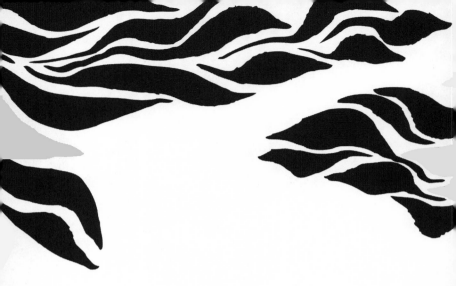

17.

Black eyed Suzie and one eyed Jill.
Those are two ladies that choose
to learn their lessons more then once.
One wears her heart on her sleeve,
bleeding pixels at 600 dpi,
the other is always a little disheveled,
so people will think she doesn't give a fuck.

He put her out like a late night cigarette,
the stifled smoke catching in the throat & mixing
with the moon and lamp light,
that now clouds her mind
as she stands at the edge,
waiting to cross the river.
The tide lapping at her toes,
arms folded, she searches the
horizon for forgiveness.

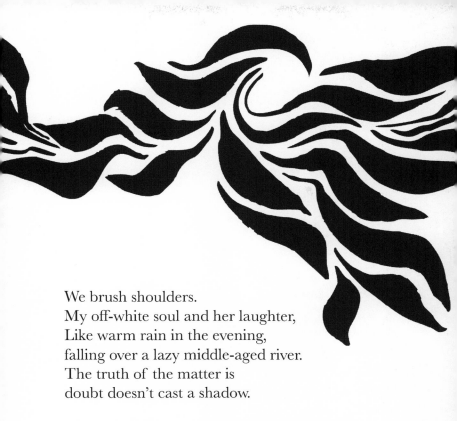

We brush shoulders.
My off-white soul and her laughter,
Like warm rain in the evening,
falling over a lazy middle-aged river.
The truth of the matter is
doubt doesn't cast a shadow.

As I untangle the crackling wallpaper patterns
plastered anew in my quarter century psyche,
she's looking by LED candlelight at our
winged lover for the first time.
She expects drag triplets from my heart,
I retort with the steady pace of a corpse.

A century of light,
candlelight, and the
yet-to-be decades of light,
hydrogen neon screens, glimmer while
we bleed pixels into haunted estuaries,
not feeling the wax we drip on our naked souls.

18.

The skin of this soul
was no longer tender.
He traced the footprints
of the sun through the
paths of the last thirty years.
Thats when he started
paying attention
to the ache in his soul.

He dreamt of her again
last night. A dream or an
act akin to it, lingering
at the fringes of consciousness,
we'll call it a dream (this dream)
engulfed him like a silent rain
falling over a vast ocean
a vacant sea
surely it had sound, but he
 didn't hear it.

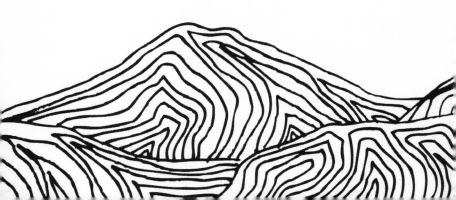

He had become a dull witness
to the cycles of the sun
like Macbeth he had murdered
sleep to rid himself of those
ebbing dreams they always
started the same way she
would remove her glasses
big dark frames that
created an odd geometry
problem on the curves of
her face. Glasses off,
she would stare at him
as if he was a rip that
suddenly appeared in the sky.

Caught in her gaze they
would sink into the folds of time.
He'd feel her breath on his skin
like moths fluttering at a flame
and he'd melt away into
the furious white heat
and sterile blue cotton
of the hospital bed.

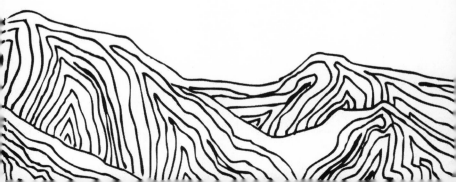

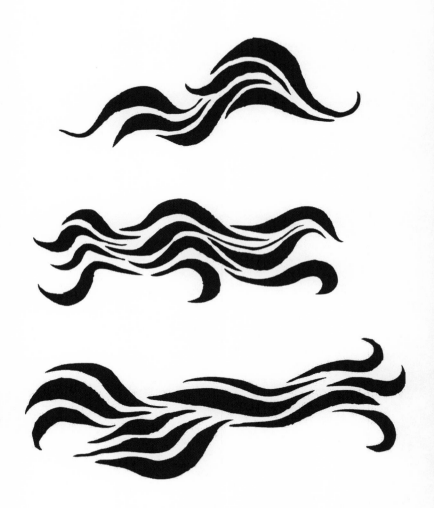

20.

His direct and unreflective experience
was a constellation
of intellectually tantalizing paradoxes
that express the human calamity
 to its fullest.

A saint praying that God will curse him
drifting in the bloodline of a barber
born in Babylon.
It's a habit of the human mind:
jumping down wishing wells.

Enveloped by the smell of an old truth,
he breathed life into her,
"there will be a dawn
of bitter fruits for tasting...."
They borrowed smiles without permission.

In an echo chamber, he spends his spare time
making nouns of verbs.
Do we really feel the bodies
we press against us
in the casual exchanges of everyday?

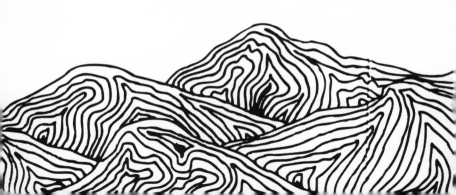

In the buzzing light of a static screen
the conversations they had
were hair down and socks on
they were just babies then,
with the blinds closed and nothing to watch.

Drunk soaking in strong doses
of manipulative irrationality
they constantly injected into each others lives.
Man's good & evil make so sense to God.
Her heart broke the day her soul was saved.

He climbed down the manhole
so he could see the light of this reclusive candle
passively presenting itself.
Sometimes a little inequality is what's really fair.

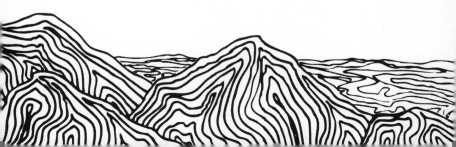

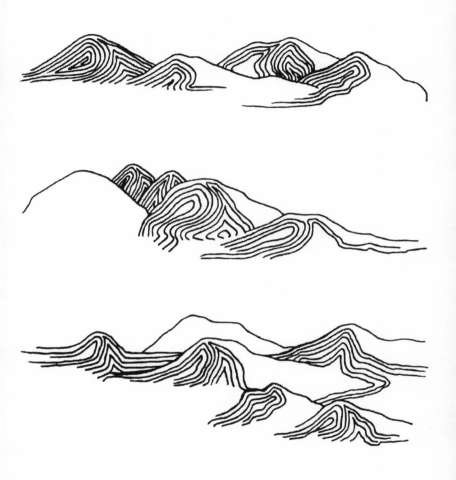

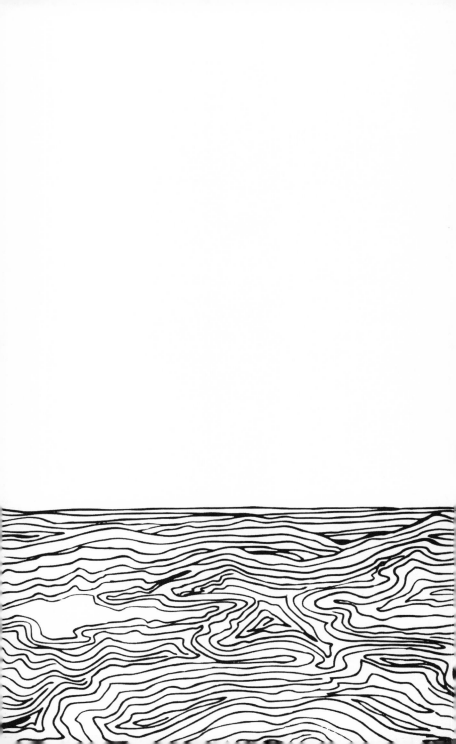

22.

Track 01

You become very quiet,
let the others fill the void.
And I wondered,
what passed behind your eyes in that silence,
it seemed to fill and complete you,
it was all I heard, the silence of your breathe.
Like plans unraveling before they could bloom,
the half smile on your lips,
a thin melancholy silver of waning moon,
I watched the stones of your pupils
drop though the surface of your iris,
into the depths of a place I've often wondered
in the dusk of my cerebral wanderings.
And I noticed when you brushed my leg,
you didn't flinch. It was natural,
our bodies brushed
and we kept on going,
living,
silently.

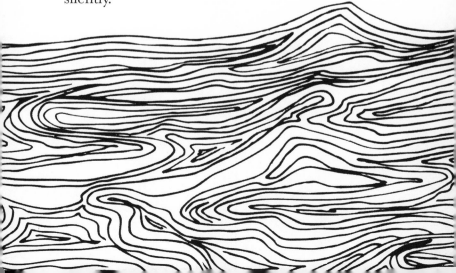

Track 02

His gentle voice made its way in,
as if slipping through a crowd.
With one of those things you have to say
in a noisy room
so you can't hear the space between your words.
So the sentiment is swallowed before
it can sink into the walls and back
into the war drum of the speaker.
Snow flakes of light dusted his face
as I turned like the mirrored ball to face him,
drifts collecting in the corners of the room.

Discontent introduced me to Hope,
haphazardly.
Hope was a wallflower,
silent and lovely.
Dressed in baby's breath teal
and deep dirty violet shadows.
Wrapped in an aura of silence,
she pressed against me
and linked arms like a whisper,
in that crowded room.

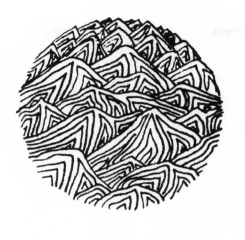

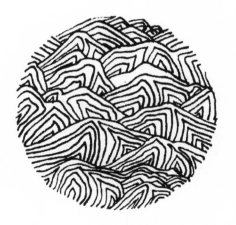

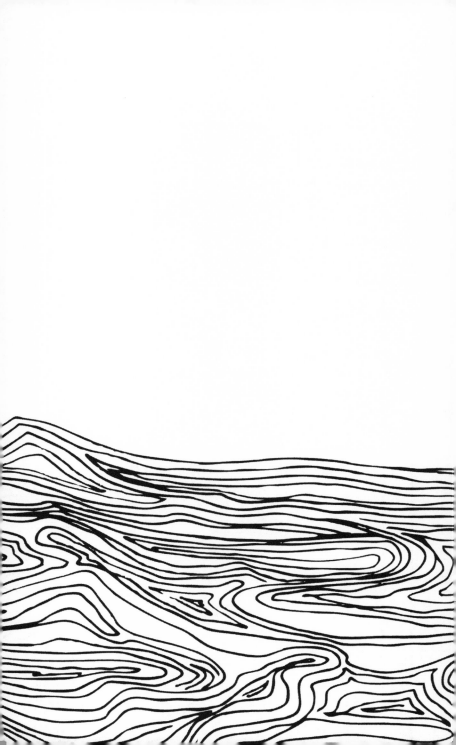

Track 03

Hoping for red lights so we can breath
as the countryside made its geographical
transformations with the ease of
a vaudeville backdrop on rollers.
Heavy lids, hungry hearts watering
the scent of honeysuckle rises
like heat from her body.
An early summer dusk
heavy haze curtain descends
on the midnight meridian.

Gears shifting into place
black on black, tires on tarmac and
the white noise friction of 75 in a 55.
Black and white, static of the radio
circulated by the air conditioner.
They head north by northwest
toward a world of grays.

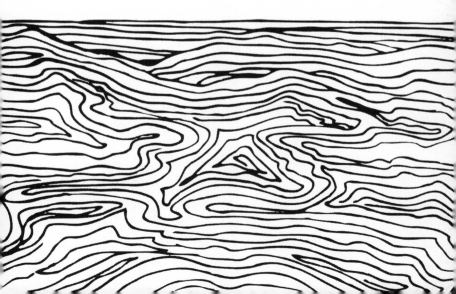

Track 04

The breath behind the door,
your white teeth, with the stains
from the smoke and anonymous liquids
of yesterday's parties. Whispers leading
us along the hallways with the maps of all
places we've never been, a tad crumpled
and faded from someone else's vacations.
How feverishly typeface became
pattern and totems.

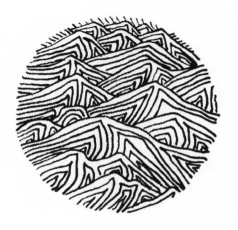

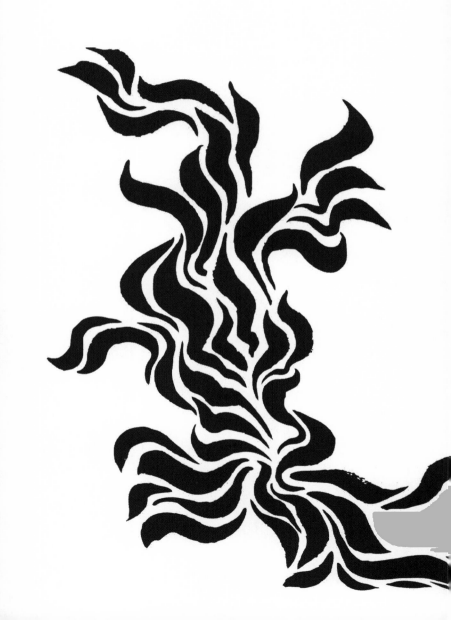

23.

With wide feet I walk on a fine line of
eggshell white. Unsurprised when the
vastness returns my stare.
These words are like driftwood,
scattered, I arrange them to suit you
and read them like bones.
Like any mystery
it says as much about the seer
as it does the seen.
Carried on the longing tides of the human heart
and reflected on the shards of the moon
drifting in Psyche's haunted estuaries.

24.

The four *P*s of America:

America is a cancer,
born in the fourth house
in the summer swelter
sent down the proverbial river

The sign read "God less America,"
where that 'b' went I'll never know,
but it seemed like some sign from him
nonethebless.

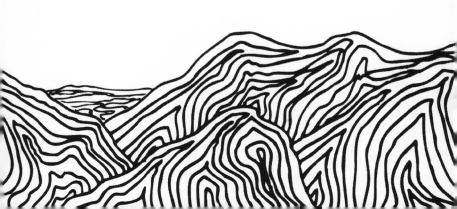

Blessed are the meek,
he didn't go on to say anything
about inheriting the earth,
the scent of the garden rose
 like heat from her body,
 a summer dusk arriving 14 minutes early.

Caught up with your words and signs
you've forgotten the language of the world
resonating from you.
This is a habit of skepticism.

She goes around Evangelicalizing cowboys.
She hasn't cut herself in years
but she still bleeds.
Laying in bed trying to feel
the arms wrapped around her.
He licks imaginary wounds,
She said, "God Bless." He said, "We'll see."

#Pilgrims #Puritans #Pioneers #Pornographers.

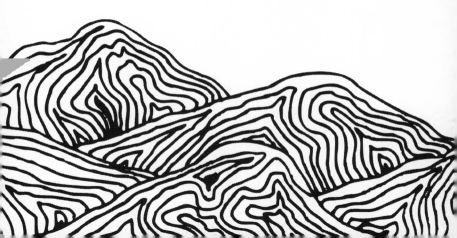

25.

Sometimes,
I catch the scent of my mother
on my words.
I fall asleep in French,
the glass falling in slow motion,
suddenly sped up, shattering.
Yet,
Time lives in the tenth house,
and appears to doze.

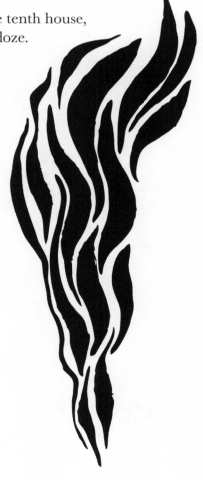

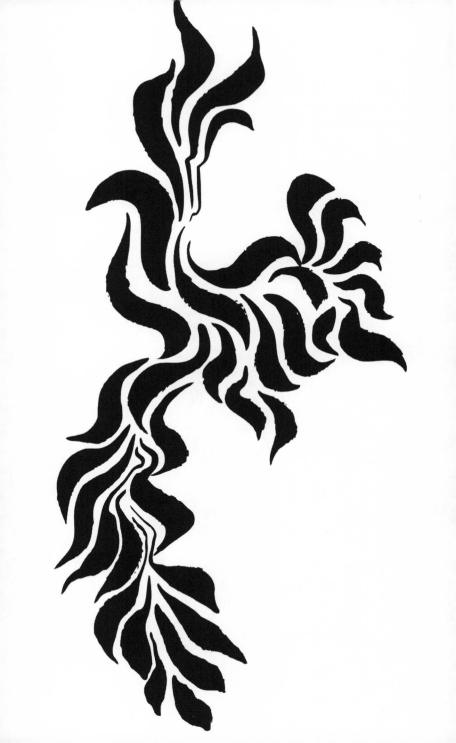

26.

Same Hell different devils
some lurk in the shadows
others hide in the light.

I see mine in hallway corners
lingering, watching me as
I pass into the next room.

Its eyes are riptides that drag
me out to a sea of lost memories
where I succumb to Hercule's folly
and chop away at the faces
each being replaced two fold.

I (had to) relocate two spiders today,
or the same one twice.
He looked smaller, the second time.
We were too big to coexist
in the same space. Even with
ten foot ceilings.

They were those people,
the ambassadors of and for
the human race #American
the way they told stories
made you certain
they were writing the footnotes
to their future biographies.

To master death,
you must give up life.

27.

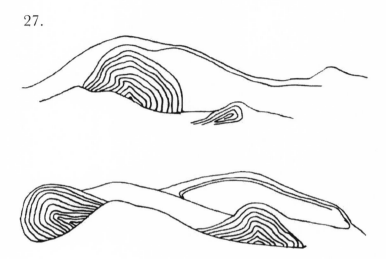

28.

My heart pounds its
bloodied knuckles
against the rib of its
cage. A brain made of
rib, a body built with
extra bars to hold
her wilder heart.

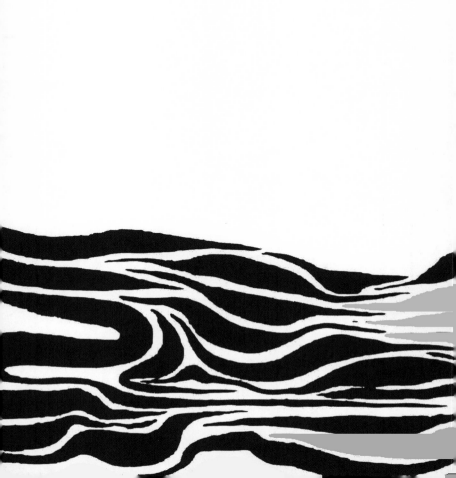

29.

So atuned to the currents
that when you realize you are
the rock, the stillness
you experience
is so complete,
it is the silence pounding
on your eardrums.

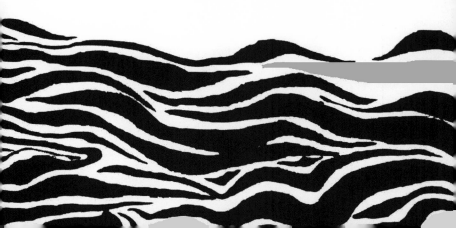

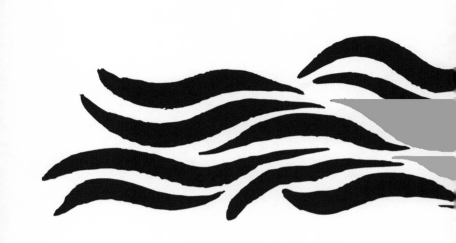

Born on a volcano and raised out of a suitcase,
Meghan Rose Morrison has dedicated her life
to creative expression. In *We Doubt The Call*,
Morrison dives into herself to emerge with
a collection of poems and illustrations. Her
nuanced expression acts like a scalpel to reveal
moments that we all share. Using more than
words, she crafts visual patterns that echo the
experiences she explores. Through her book
we can share her journey.

http://www.meghanrosemorrison.com

Made in the USA
Middletown, DE
23 November 2018